from the ωεΠϛρπιηζ:

FAITH, SOIL, TRADITION

folk arts from Ukrainian culture in North Dakota

Author: Troyd A. Geist

Editor: David Sprunger

Publication Design: Wendy Scheuerman Schweitzer

Published by the North Dakota Council on the Arts

International Standard Book Number: 0-911205-97-7

Additional copies of this publication may be purchased from the North Dakota Council on the Arts.

Printed in the United States of America.

First Edition

Cover Photo: Close-up of embroidery by Ann Basaraba, Fairfield, ND.

This publication is supported by the North Dakota Council on the Arts, an agency of the State of North Dakota,
and by grants from the North Dakota Humanities Council, and the Lila Wallace-Reader's Digest Community Folklife Program,
administered by The Fund for Folk Culture and underwritten by the Lila Wallace-Reader's Digest Fund.
Additional funding support was provided by the Ukrainian Cultural Institute.

Contents

Foreword

Robert Conquest's great book, *Harvest of Sorrow,* spells out in detail the enormous suffering that the Ukrainian people have gone through in this century. As one studies many of the previous centuries, one sees the story of a people of great courage and faith facing great adversity. Conquest's book gives a gripping account of the suffering in the 20th century, but one must go back through the centuries to such epic events as the Mongolian invasion of the 13th century to get a better understanding of the great faith and perseverance of the Ukrainian people. There were 400,000 horsemen that invaded Ukraine and conquered the land. This led to two centuries of Mongolian rule. Each ensuing century has its own story.

Central to understanding the art and Ukrainian cultural heritage of North Dakota is the role of faith in the midst of adversity and in the midst of bounty. There was no sacred, secular dichotomy characteristic of many in the late 20th century America. As you read this book you will understand this reality.

There are many who have contributed to this wonderful book. Of special note I would like to acknowledge Agnes Palanuk, Executive Director of the Ukrainian Cultural Institute, and Dr. Timothy J. Kloberdanz of North Dakota State University. Those of us on the Arts Council have grown to deeply appreciate Troyd Geist for his firm devotion to preserving the artistic heritage of our state. This work will assist in that noble effort. Most of all, I would like to thank the folk artists who participated in this project for their undying commitment to preserving these art forms.

Howard Dahl, Chairman, North Dakota Council on the Arts

Acknowledgements

NDCA Board Members:

Howard A. Dahl (Chair)

Mae Marie Blackmore (Vice Chair)

Joe Alme

Mary Huether

Joyce Lusk

Dolores Mutch

Nancy Jones Schafer

David Trottier

Rex Wiederanders

Dan Hoffmann (past member)

Mary Louise Defender-Wilson (past member)

NDCA Staff:

Patsy Thompson, Executive Director

Wendy Scheuerman Schweitzer,

Community Services Coordinator

Troyd A. Geist, Folklorist

Eileen Bittner, Administrative Assistant

Photographers:

Amy Anderson

D.J. Arnold, D.J. Arnold Photography

Roy and Ann Basaraba (courtesy photos)

Katrina Callahan

Troyd A. Geist

Dan Koeck

Christopher Martin

Josie and Bill Namyniuk (courtesy photos)

Martha Namyniuk (courtesy photos)

Agnes Palanuk (courtesy photos)

This publication is funded by the North Dakota Council on the Arts and grants from the North Dakota Humanities Council and the Lila Wallace-Reader's Digest Community Folklife Program, administered by The Fund for Folk Culture and underwritten by the Lila Wallace-Reader's Digest Fund. The Ukrainian Cultural Institute also contributed funds toward this publication.

This publication is based on the North Dakota Council on the Arts' traveling exhibition by the same name. For booking information contact the Council at 701-328-3954.

Mirrors of Culture, Cycles in Time

North of the Black Sea, bound by the Don River to the east and the Carpathian Mountains to the west, lies a vast expanse of dark fertile land known as Ukraine. The rolling steppes and serpentine river valleys of this land have been cultivated for several thousand years, producing fields of wheat, flax, and rye, and orchards of apples, cherries, and grapes. Due to its wealth of natural resources and its reputation as the "Breadbasket of Europe," Ukraine often came under the envious eye of other powers. Throughout history, it has been controlled by Tartars, Turks, Austrians, Poles, and Russians. Despite these outside influences, two things remained constantly entwined: the land and the folk culture of the people tied to the land.

Ukrainian life and culture became intimately connected to agriculture, especially the cultivation of wheat. Because Ukrainians were dependent upon farming for their livelihood, they were well aware of nature and of the lessons it can teach. With the coming of spring, seeds are planted to grow in the longer days of the sun's rays. As fall approaches, the days grow shorter. The grain matures, and it is harvested. A period of dormancy ensues only to be reborn with the perpetual cycle of life. So profound were these forces that farmers came to perceive the agricultural or secular cycles as a reflection of religious cycles: each the mirror of the other. In turn, a strong perception of the world consisting of themes of fertility, renewal, life and death, resurrection, rebirth, and a trinity was created in the farmers' hearts and minds. From these thoughts emerged traditions reflecting and communicating this mirrored worldview.

Nourished by a wellspring of faith, the Ukrainian cultural heritage flows forth as rich as the soil from which it came, a heritage embodied by highly symbolic and integrated traditions. These traditions include the folk arts of embroidery, decorative ritual bread making and wheat-weaving, *pysanky* (decorated Easter eggs), and *cymbaly* (hammered dulcimer) making and playing. All of these folk arts are integrated into the lives of the tradition-bearers. They take place within a familial, social, and often religious context, providing an identity that follows the individual from cradle to grave, marking significant moments in a person's life. In addition, they are connected to each other through

association and shared symbols. For example, a traditional Ukrainian wedding celebration is not complete unless it involves a ritual wedding bread, a wedding *rushnyk* (embroidered ceremonial cloth), and the playing of the *cymbaly*. An Easter basket is not complete without ritual Easter breads, an embroidered Easter basket liner and cover, and *pysanky*. Similarly designed eight-pointed stars, crosses, wheat, birds, and geometric patterns can be found in all of these arts.

The integrated nature of these folk arts have their roots in pre-Christian traditions. With the advent of Christianity and its acceptance by Ukraine in 988 A.D., Ukrainians found that Christian beliefs meshed well with their pre-Christian worldview. Both views stressed the themes of eternal life, fertility, renewal, rebirth, a belief in a supernatural trinity, and life after death. As a result, many pre-Christian traditions were incorporated into Christianity, and they continue today. In essence, these themes and their manifestation in symbols and celebrations remains the same.

By the 1800s Ukrainian farmers had access to only small tracts of land, acreage too small to support their large families. This created a "land hunger" that enticed many Ukrainians to emigrate in the late 1800s and early 1900s. Some of those immigrants landed on North Dakota's prairies, establishing farms around towns like Belfield, Fairfield, Ukraina, Dickinson, Kief, Pembina, and Bathgate. While starting over in a new land, these immigrants clung to what was familiar: their identity, traditions, and folk arts. This text focuses on some of the folk arts as continued today by the descendants of these immigrants. The folk artists featured are considered, within their own communities, to be among the best at what they do.

Embroidery

Embroidery is found throughout Ukraine as it is throughout the Ukrainian community in North Dakota. Colored cotton thread is used to form many kinds of stitched designs on burlap and polyester-cotton cloth. The three most popular stitches are cross-stitch, a reverse stitch called *nyzynka*, and a weaving stitch called *zavolikania*. Certain techniques, designs, symbols, and colors represent different areas of Ukraine and are specific to particular items. Ann Basaraba (Fairfield), an embroiderer, writes, "When you make a [woman's] blouse, you use certain patterns. A man's shirt has a different pattern. Small children's blouses are different. It's the same for [other things]. The colors are important. You can't mix your bright colors with dark, dull colors. You have to use bright colors all the way or dark colors all the way. The colors used on

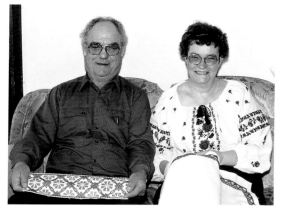

Ann, wearing an embroidered blouse, and Roy Basaraba displaying embroidery in their home. "While Roy sings, I embroider," Ann says.

an item depend on the age of the person for whom it is made. Dull, dark colors are used for elderly people. Light, bright colors are used for young people. [Also,] yellow and blue are used because that's the Ukrainian colors. It's on the [Ukrainian] flag. Yellow stands for fields of grain and blue for the sky."

Pearl Basaraba embroidering a pillow cover.

Flower embroidered on burlap.

For Ann, embroidery is not only an ethnic tradition but a family tradition as well. She says, "I came from a family of 17 people. I have done needlework since I was 10 years old. ... I began Ukrainian embroidery [over 25 years ago] when I married Roy. [His mother], Pearl, started me on burlap.

I remember it being a big change for Pearl to move from burlap to [polyester-cotton] cloth." Pearl Basaraba was born in Ukraine in 1896. At the age of seven, she came to North Dakota with her parents and siblings. When they emigrated, Pearl's mother and older sister brought embroidery samples from the "Old Country" to use as patterns. Pearl learned from her mother and sister. She later taught Ann. Ann, in turn, taught many other people including her daughter Stephanie Klym and niece Colleen Rodakowski (Belfield).

"For my mother, Pearl, doing embroidery was next to praying."

—Roy Basaraba

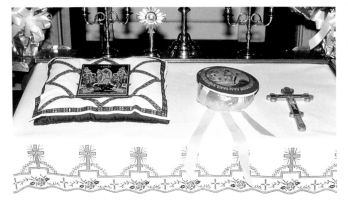

Embroidered altar cloths used at St. Demetrius Ukrainian Catholic Church south of Fairfield, ND. Ann Basaraba explains, "I never work on something on a Sunday, if it's for sale. I will, if it's for charity. Most of the things I make, I give away."

Ukrainian embroidery appears in the secular world as well as in the sacred realm. Embroidered pillows, dance shirts and sashes, tablecloths, table runners, and wall hangings beautify the home in a burst of colors that span the rainbow. The patterns include geometric designs, crosses, "rosettes" or eight-pointed stars representing Jesus Christ, and spring floral motifs such as roses and vibrant red poppies, a very popular flower among Ukrainians. In the sacred realm, *rushnyky* (plural, embroidered towels or cloths) are used for religious or ceremonial occasions. Ann has embroidered altar cloths, purification cloths, and stoles for the priests at her church. "On the purification cloths, I've made flowers, crosses, chalices, grapes. [Grapes are symbols of the growing church,] and the color purple represents Communion," states Ann. In addition, embroidered scarves are draped in reverence over religious icons that occupy a corner of many Ukrainian homes. When a person dies, a similarly embroidered scarf is draped over a picture of the deceased.

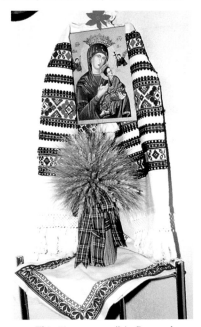

This "icon corner" in Roy and Ann Basaraba's home has a didukh, *embroidered scarf, and religious icon.*

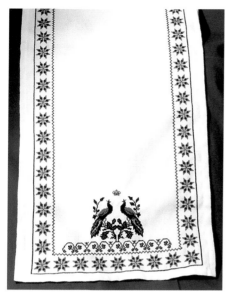

Ceremonial wedding cloth, rushnyk,
made by Ann Basaraba.

The *rushnyky* follow a person throughout the year as well as during the defining moments of his or her life. Such moments include the birth of a child, baptisms, weddings, funerals, and Easter. Traditionalist Josie Namyniuk (Belfield) states, "When a baby is born, a gift of an embroidered towel is to be given to the baby." For a baby's baptism, a cross is embroidered on the white cloth used in the ceremony. For Ann and Josie, the use of the *rushnyky* in ceremonies before weddings and at wedding receptions is essential. Before the wedding ceremony at the church, the family holds a separate ceremony at the bride's house. At various points in this ceremony, the bride and groom kneel on a *rushnyk* (singular), made by the bride's mother, to receive their parents' blessings. Roy has been a master of ceremonies for many weddings. He explains that "[At the reception,] the *rushnyk* is used again. ... The master of ceremonies attempts to put a *rushnyk* over the couple's heads. Then he backs off and approaches a second time as if to put the cloth on the couple's heads again. He backs off. On the third approach, the *rushnyk* is tied like a *babushka*. It is done three times for the Holy Trinity. On the third try, it is tied together as two people unite for eternity." The covering of the bride's head indicates she is now a married woman. These matrimonial towels are beautifully embroidered by people like Ann. A design she has used includes two peacocks facing one another and sitting upon a "Tree of Life." Peacocks and other birds are symbols of human souls. A crown is embroidered above the birds. The birds represent two families coming together to form another family or branch in the "Tree of Life." The crown represents God's blessing and guidance of the union as the tree grows toward Heaven. All four sides of the cloth may be embroidered with eight-pointed star or sun symbols representing fertility, Jesus Christ, and God's love toward Man.

The folk art tradition of making and using intricately embroidered cloths is so closely associated with the themes of life, death, and resurrection that they take their place among one of the most profound points in the human cycle: death. Coffins of the deceased used to be lined with embroidery. Now, however, the cloths are draped over the coffin for funeral ceremonies held at the church and at the cemetery.

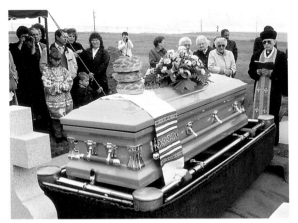

Pearl Basaraba's coffin draped with traditional embroidery and breads.

When embroiderer Pearl Basaraba passed away in 1995, for example, her coffin was adorned with embroidery as a tribute to her life, talents, and traditionality.

Some of the most stunning and elaborate *rushnyky* are those made to line and cover baskets of food that are blessed by the priest at Easter celebrations. People take great pride in the detail of their basket liners and covers. The ornamentation includes elaborate geometric designs, colors, and motifs with various meanings. For example, butterflies may be embroidered since it is believed that butterflies represent resurrection, because just as butterflies emerge from cocoons, Christ arose from the tomb. Some liners and covers are embroidered with illustrations of decorated Easter eggs and the phrase "Christ Has Risen" in the Cyrillic alphabet. Pussy willow designs are used as suggestions of life anew. In pre-Christian thought, willows, due to their early emergence, were associated with the new life of spring. This association is so closely connected to Easter that instead of using palms on Palm Sunday, Ukrainians often use pussy willows. With regard to appropriate colors used in this embroidery work, Ann notes, "Very little black is used on Easter basket liners and covers, because black is a sign of mourning. Easter is a celebration [of life]."

Embroidered Easter basket cover decorated with a butterfly and flowers.

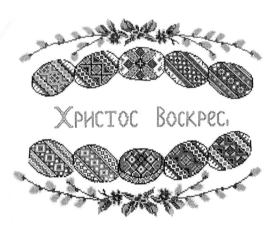

Христос Воскрес.

Easter basket cover embroidered with pussy willows, Easter eggs, and the words "Christ Has Risen" in the Cyrillic alphabet.

Decorative Ritual Bread Making and Wheat-Weaving

Traditional Ukrainian life depended upon wheat for sustenance. It was life, so to ensure a good life, it was necessary to produce a good harvest, and to ensure a good harvest, wheat was brought into the realm of the sacred. Josie Namyniuk and her son, Ray (Belfield), remember, "When we would harvest and the bundles or shocks of wheat were collected we would say a prayer [asking], 'May these bundles be good.' The people would get off their tractors and kneel in the soil and thank God before harvesting what He gave. Grandpa would kneel down, look up at the skies, and thank God."

For Ukrainians, as for other agricultural people, wheat and bread are not just nourishment for the body but for the soul as well. This is revealed in the traditions of wheat-weaving and ritual bread making and decorating. Wheat drifts in an air of religion and the supernatural. Martha Namyniuk (Belfield) recalls, "My dad, on New Years, would put straw crosses in every window to ward off hurtful things like spirits or storms. I remember helping my father make those crosses." While wheat is thought to have protective powers, its main association, however, is with life and fertility. Martha weaves wheat into "house blessings" that represent a bountiful life and harvest. These triangular "blessings" are made from 26 heads of wheat, 13 on each side representing Jesus Christ and the 12 Apostles. The weaving is made from the first wheat cut in the fall, and it is saved until spring when its seeds are among the first to be sown to guarantee food for the following year. It is said that if these weavings are hung in the kitchen, the occupants "will never go hungry."

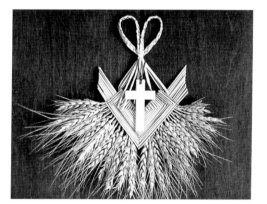

House blessing made by Martha Namyniuk.

Like embroidery, bread and wheat plays an active part in the secular and religious life of Ukrainians. Martha states, "My mom baked bread practically every day. My mom used to bake bread in the *pich* [outdoor, earthen stove]. ... Kids used to sleep on the *pich* to keep warm." Josie adds, "When the women baked breads in the earth stoves, they would make 20 at a time." Some breads are simply made; others are elaborately braided and decorated. These elaborate, symbolic breads incorporate specific designs for specific occasions. A *babka* and *paska* are made for Easter; three-tiered *kolachi* (plural), for Christmas; a *korovai*, for weddings; and still other breads, for welcoming and funeral ceremonies.

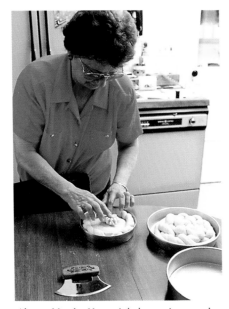

Above: Martha Namyniuk decorating a paska.
"If you drop bread you are to pick it up and kiss it in respect," explains Martha.
Below: She shows a dough "pine cone" to be placed on the main body of bread dough.

A *babka*, for example, is a cylindrical, sweet-tasting bread that these days is often baked in a coffee can. Its rounded top is sometimes glazed with a sugar frosting. Its taste reminds us of the sweetness of life. A candle is inserted into the top of the *babka* as a suggestion of the spirit of Jesus Christ resurrected. The *paska* is a round bread whose top is decorated with various symbols like crosses for Christianity, flowers for spring, rosettes for Jesus Christ, doves for the Holy Spirit, and pine cones for fertility. Both a *babka* and *paska* are always included among the foods contained in the embroidery-lined Easter basket blessed by the priest during Easter ceremonies. Ukrainian artist Rita Zaharia (Bathgate) adds, "Food that's blessed at Easter tastes twice as good as the food that is not."

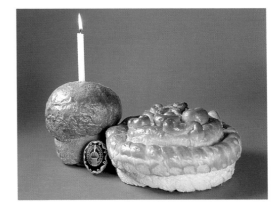

Ceremonial Easter breads made by Betty Baranko and Martha Namyniuk and pysanka *by Angie Chruszch.*

These ritual breads are inherently symbolic of wheat and fertility. Even the word *babka* gives us a clue to this meaning and to the tradition's relationship to women. For example, Martha explains that when she was a little girl helping her mother make Easter breads, her mother referred to the bread *babka* in another way, *baba*. Martha remarks, "I remember asking my mom, 'Why are you calling that bread Grandma?'" The word *baba* is the diminutive form of the word *babka*, and it is used when referring to "grandmother" in a familiar, affectionate way and when referring to this particular kind of Easter bread. Historically, Ukrainian culture was matriarchal. Women held positions of authority and were key to ceremonies associated with the fertility of the soil. It is believed that *babka* bread was used in such ceremonies. Even until quite recently, a piece of bread was turned over in the first furrow of the field in spring in the belief that the life-sustaining property of bread would transfer to the soil. In return, the soil would produce a hearty crop.

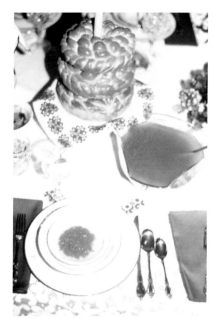

Boiled wheat, or kutia, *at a traditional Ukrainian Christmas Eve meal.*

Wheat and bread occupy a prominent place in Ukrainian households at Christmas Eve. According to Josie, "The first wheat cut in the fall would be put in the house for the entire year and placed above a holy picture. Sometimes it was the wheat boiled for Christmas." This boiled wheat is mixed with honey and crushed poppy seeds to make *kutia*, an ancient dish. *Kutia* is among the first foods eaten on Christmas Eve. Straw placed under the supper table and under the embroidered tablecloth reminds diners of Jesus Christ's birth in a manger.

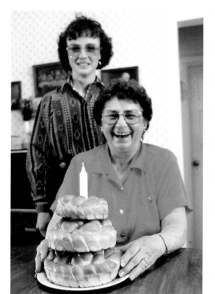

Martha Namyniuk and Carolyn Basaraba with the Christmas kolachi *they made.*

A *didukh* and special *kolachi* (plural) serve as centerpieces for the Christmas Eve meal. The *didukh*, meaning "forefather" in Ukrainian, is a sheaf of wheat tied with embroidery or woven straw. A reminder of deceased family members, souls, this wheat is saved and mixed with the wheat planted in spring. In

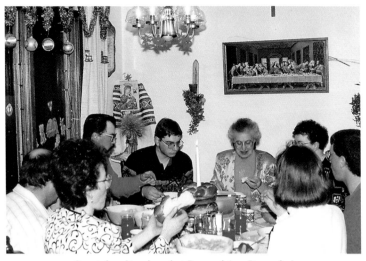

Guests breaking bread at Roy and Ann Basaraba's Christmas Eve meal. Notice the didukh *in the icon corner and the* kolachi *in the center of the table.*

relation, a special plate is often set for the deceased during the Christmas Eve supper. The other centerpiece, the *kolachi*, is a round, three-tiered bread topped with a candle. Individual *kolach* (singular) are made by braiding three strands of dough and are set one upon the other. The repetition of the number three is indicative of the Holy Trinity. This bread serves as a reminder of Jesus Christ as "the Bread of Life," and the candle indicates He is "the Light of the World."

The *kolach* plays a role in many ceremonies including welcoming ceremonies. For example, Betty Baranko (Fairfield) recalls, "[On Christmas Day,] carollers would be welcomed in with a *kolach*. Wine would be waiting inside. [Also,] when the priest blessed the house, he would be given a *kolach*." In such cases, welcoming breads are topped with a cube of salt because just as salt never goes bad neither should the friendship between the presenter and recipient.

Just as embroidery marks significant points in a person's life, so do ritual breads. For

> "I've been making the Communion bread for St. Demetrius for 30 years. You don't abuse bread. Not a crumb! It is special. Bread is life."
>
> —Josephine Gregory

example, a *kolach* is used in wedding ceremonies held at the home. In this ceremony, the bride's mother puts a veil on her daughter's head and blesses her with a stem of periwinkle dipped in Holy Water. As the soon-to-be bride and groom kneel upon an embroidered wedding cloth, their parents bless the couple with a *kolach* held above the

A welcoming bread offered to a priest at the St. Demetrius Ukrainian Catholic Church south of Fairfield, ND.

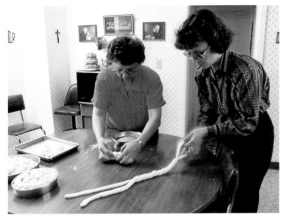

Martha Namyniuk, left, and Carolyn Basaraba braiding dough.

bride and groom's heads. Later, this *kolach* reappears at the reception table as a centerpiece set before the married couple. Josie reminisces, "When I was married, we had, at the reception, a small evergreen decorated with flowers, and the tree was set in a *kolach* like a holder."

The most elaborately decorated ritual bread used for weddings, however, is the *korovai*, a large, sweet-tasting bread. It is made by weaving three strands of dough into three large braids. The braids are placed into a circular baking pan to denote eternity, "never a beginning and never an end." The baked bread is decorated with baked decorations, such as doves for the husband and wife united in love and happiness, pine cones for fertility, rosettes for God, and flowers for beauty. Then the *korovai* may be decorated further with red poppies and green periwinkle to suggest

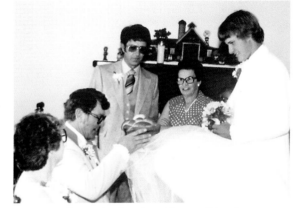

Decorative bread used in a traditional Ukrainian wedding blessing.

renewed life. The *korovai* is served like a wedding cake at the reception, though it is treated with much reverence. Martha elaborates, "Everyone in the community is supposed to contribute something to the making of the *korovai* to show good thoughts and support for the couple. [When it is served,] you are supposed to break the *korovai* with a cloth. You can't cut it. To stress purity and [to prevent bad thoughts from entering] the bread, metal and [human] hands are not suppose to touch it."

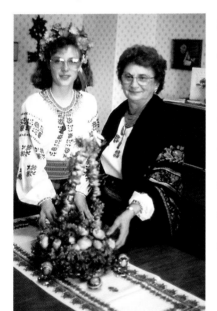

A wedding korovai *made by Martha Namyniuk, right, and Carolyn Basaraba.*

Kolachi are also used with embroidery in funeral ceremonies to mark the passage from one life to the next. Bread and wheat remind mourners that the emphasis of the funeral is on life, not death.

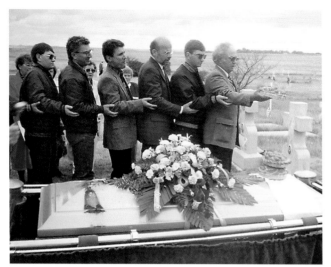

Roy Basaraba, front with bread, and others offer prayers to Heaven in mourning the loss of Roy's mother.

When a person dies, the coffin at the church is draped with embroidery and *kolachi* topped with a lit candle are placed at the coffin's head. The candle serves as a flickering reminder that life still exists for the deceased. As the coffin is moved to the cemetery, so are the bread and embroidery. At the cemetery, a ritual takes place wherein a line of men related to the deceased stand behind one another, each one holding the other's right elbow in support. The person at the head of the line holds a *kolach* which is raised skyward three times. "The lifting up of the hands are used to lift the prayers of the mourners to Heaven [through the offered bread]. And the people sing a song, *Eternal Memory*, to put the soul of the deceased to rest, to ensure a place of peace among the saints," recalls Roy Basaraba (Fairfield). "I can't paint a picture of how beautiful the ceremony is. ... Then after the person is buried, the *kolachi* are taken back to the church and served to the mourners [in remembrance] at the meal. We did this for my mother, Pearl, when she died."

Pysanky

*T*he Ukrainian egg decorating, *pysanky*, tradition is thousands of years old. It is a pre-Christian tradition with roots in ancient nature-based, sun ceremonies. These ceremonies were held in the spring to welcome the return of the sun's regenerative, life-giving powers. The egg, which contains the essence of life, became associated with the sun's powers and was, thus, used in ceremonies to magically aid the sun. The egg's yolk was associated with the sun and the egg white with the moon. Solar- and nature-based symbols like the sun, moon, stars, plants, and animals were drawn on eggs in an attempt to influence nature. In fact, one of the earliest symbols was the eight-pointed star, a magical representation of *Atar*, a sun god.

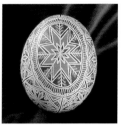

Pysanka *with eight-pointed star motif made by Rita Zaharia.*

Pysanka *with crescent moon, periwinkle, and star design made by Marjo Hurinenko.*

Remnants of this belief in the magical transference power of *pysanky* continues today in Ukrainian oral tradition and practice. Take the moon symbol, for instance. Many agricultural people have a rich body of lore regarding the moon's relationship to the growth of crops; some people "plant by the moon" to increase their chances for a better yield. In addition, in historically matriarchal societies like that of Ukrainians, the moon is related to the fertility of women. Women decorated the eggs to be used in spring ceremonies whereby the fertile power of the egg would transfer to the soil. A survival of this tradition continues today. Ukrainian traditionalist Martha Namyniuk (Belfield) states, "You bury an egg in the first furrow you turn in spring. It ensures a good crop. I do that, and I get good crops." The use of moon symbolism on *pysanky* may be related to this ancient practice. There are other examples of the talismanic power of *pysanky*. Josie Namyniuk (Belfield) mentions, "If a big storm

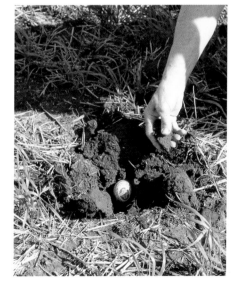

Martha Namyniuk burying a pysanka *in her wheat field.*

15

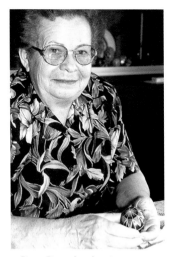

Betty Baranko showing an egg she decorated for Easter.

was coming we would take the palms from Palm Sunday and go outside and make a cross and lay it on the ground. Years ago they didn't have palms. They had pussy willows. The willows were used to make crosses to protect against storms. Also, the eggs, [*pysanky*], were put in the window sills to protect against storms. Those eggs would often have pussy willow designs on them."

With the arrival of Christianity, the *pysanky* tradition with its emphasis on renewal, life after death, and fertility merged especially well with the Christian Easter celebration with its emphasis on eternal life attained through Christ's Resurrection. In fact, they fit so well that, now, decorated eggs have become synonymous with Easter. While new Christian symbols were added to the *pysanky*, pre-Christian symbols were also retained but with new Christian meanings attached to them. For example, *Atar*'s eight-pointed star or sun symbol came to represent Jesus Christ, the Son of God. The triangle originally representing the naturalistic trinity of fire, water, and air, came with Christianity to represent the Holy Trinity of the Father, Son, and Holy Spirit. Even the moon symbol survived, though it is used rarely.

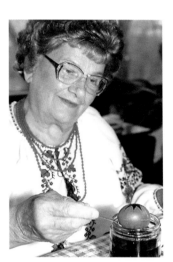

Julia Hurinenko removing a pysanka from a dye bath.

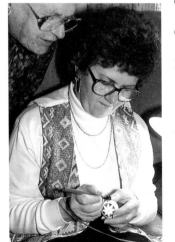

Angie Chruszch working on a pysanka design while her mother, Katie Logosz, watches.

Pysanky remains one of the most enduring, spectacular, and meaningful traditions among Ukrainians. This tradition was and is passed through the generations from mother to daughter, though a few men also decorate eggs. When Ukrainian farmers came to North Dakota, mothers and grandmothers made a conscious effort to encourage their daughters to learn this important art. Now, this elegant tradition rests and flourishes in the hands of exceptional artists like Betty Baranko (Fairfield), Angie Chruszch (Belfield), Julia and Marjo Hurinenko (Manning), and Rita Zaharia (Bathgate).

Marjo Hurinenko looking at her etched eggs on display at the Ukrainian Cultural Institute.

The making of *pysanky* begins with selecting eggs. This is such an important step that some *pysanky* artists like Betty and Rita raise their own chickens for the express purpose of producing eggs to be decorated. Betty says, "I gather eggs three or four times a day to make sure those eggs don't get scratched. [The shells] have to be firm, smooth. They can't be oily or else the dye won't take evenly. California Whites lay the best eggs. You have to be careful what you feed them. I gave them old lettuce once, and they laid oily eggs. Give them wheat, grains." Betty notes that the best eggs are produced in the spring.

Once the eggs are collected, they are ready for decorating. For many *pysanky* artists, the egg decorating tradition is treated with reverence. "Before I begin an egg, I cross myself and say a prayer to God, and the Virgin Mary guides my hand," says Rita. Even though the *pysanky* tradition is pre-Christian, folk legend relates its origin to the Virgin Mary and Jesus Christ's crucifixion. It is said that when Pontius Pilate was crucifying Jesus Christ, the Virgin Mary stood below the cross, holding an apron full of eggs. As she cried, her tears fell upon the eggs as did drops of blood from Jesus' wounds. The blood and tears mingled to form beautiful, elaborate, and colorful designs. The Virgin Mary then knelt before Pontius Pilate to offer him the eggs as a sign of forgiveness. As she knelt, the eggs rolled from her apron. They rolled and rolled and spread throughout the land, and where they stopped is where the egg decorating tradition grew.

In Ukrainian folklore, pysanky are associated with the Virgin Mary. Rita Zaharia, who says "eggs are like prayers," shows some of her pysanky.

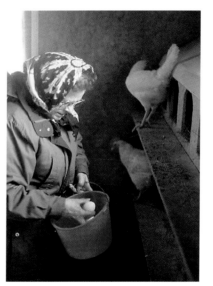

Betty Baranko gathering eggs in her chicken coop for making pysanky. *"I tell them to lay smooth eggs," she jokes.*

With the prayers said, the artist begins the decorating process with a series of beeswax applications in which designs are drawn on uncooked, room temperature eggs using a tool called a *kistka*. In the past, the *kistka*

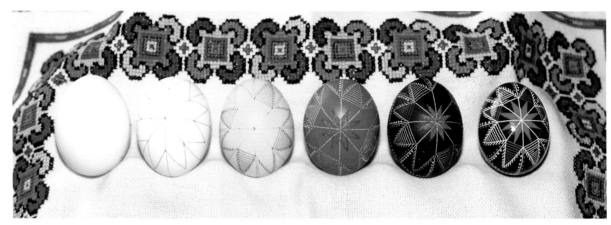

Progressive stages in the design and color development of a pysanka.

was a small funnel attached to a willow stick. Wax in the funnel was heated over a candle flame so that the molten substance would flow from the point of the funnel to the surface of the eggs. Thus, designs were drawn on the eggs. There were other methods of applying the wax. For example, Mike Baranko (Fairfield) remembers, "As a little boy, my mom would send me to the [pig pen] to pick bristles off a hog's back, on the neck. The bristles would be used to make her *kistka*. The hog's bristles are rigid enough and pliable enough [to be used] like a paint brush [when it's attached to a willow stick]. Boy, would the hog get mad!" Now, however, artists often use an electric *kistka*. The wax flows smoothly and evenly through its pencil-like funnel so that even more precise designs can be drawn. After the wax is applied, the eggs are dipped in a dye. The wax resists the dye, leaving the color beneath undisturbed. Then they are dipped in a second dye bath. Wax applied over that second color protects it from changing with subsequent dye baths. Beginning with the lighter colors, this process continues as many times as there are colors needed for the designs. Once the eggs are finished, the wax is removed by holding the eggs over a candle flame or by placing them in a low temperature oven.

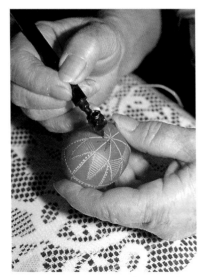

Betty Baranko using an electric stylus, or kistka, *to apply molten wax to an egg.*

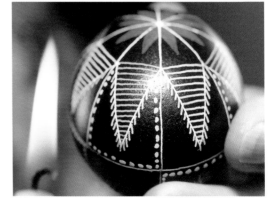

The final stage in making a pysanka *is removing the wax.*

The dyes used in creating the *pysanky* are now commercially made. Not too long ago, however, the dyes were made from natural materials. "My mother had a cow she milked all the time, and she would follow the cow around with a little basket and pick plants and weeds for dyes. Dandelion heads were used to make a yellow dye. Dandelion leaves, for green dyes. Crocus flowers, for pinkish-purple colors," says Josie. Julia adds further insight: "The dyes Mother made were from onion skins. You would get tans and dark browns. Also, she boiled crepe paper [in water] and vinegar. ... We made dyes from indelible pencil. We would take the lead out of the pencil and boil it. It makes the most beautiful purple."

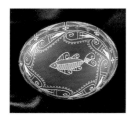

Pysanka *with fish motif made by Betty Baranko.*

Together, the designs and colors used on *pysanky* convey messages, commentaries, or wishes. Every design and symbol has a meaning. Every color has a meaning. When the individual designs and colors are put together and "read" as a whole, they tell a story. For example, Betty makes *pysanky* with geometric netting designs and fish. The fish is an ancient symbol for Jesus Christ as the "fisher of men." The netting suggests the separation of good and evil. Appropriate colors for this egg may be orange for strength and red for hope or spirituality. As a whole, the designs on these eggs comment upon the belief in baptism and may be an appropriate gift for a baptism. Betty also makes *pysanky* by combining the traditional motifs of wheat and grapes with the appropriate colors of yellow, purple, and black. Wheat is a symbol of fertility, grapes of "the growing church," yellow of reward, purple of faith, and black of eternity. She calls this combination "Bread and Wine." Such *pysanky* are obvious commentaries on the Christian Communion and would be an appropriate gift for someone's first communion.

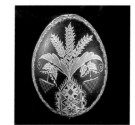

Pysanka *with "Bread and Wine" motif made by Betty Baranko.*

The innumerable designs "drawn" on the eggs vary from person to person, place to place. "It's like finger prints. Everybody has a little different style. It's their touch. No two are exactly alike," explains Martha. For example, Betty is well-known for her intricate, highly geometric designs and for her innovative combination of traditional designs. Julia, who has been decorating eggs for over 75 years, is one of very few artists who use such ancient solar symbols as the moon. She is noted for interpreting each color and symbol used on the eggs so that,

combined, they tell a "story." Marjo's work is identified by her illustrative scratched eggs. Scratched eggs are dyed a solid color then a sharp

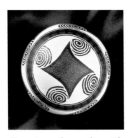

tool, like a razor or needle, is used to etch designs in the shell. Angie often uses designs given to her by her mother, Katie Logosz. Angie is recognized for her brightly illustrative designs and for her freewheeling Trypillian designs. Rita creates richly antique-looking *pysanky* from brown eggs instead of from the more common white eggs. She is known also for her "stained-glass" *pysanky* in which the wax is not removed. All the eggs are elegant reflections of faith and tradition.

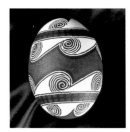

Top view of pysanka *with Trypillian design created by Angie Chruszch.*

Side view of pysanka *with Trypillian design.*

Pysanky sometimes are made for baptisms, weddings, and even for Christmas presents. They once were placed in the coffins of the deceased as a reminder of life reborn. Yet, they remain foremost and utmost an Easter tradition. The apex of Easter is Easter Sunday when a basket of food is taken to church to be blessed. This basket must contain *pysanky*, an embroidered basket liner and cover, a *paska*, and a *babka* with a candle. The *pysanky* are not eaten, but hard boiled eggs dyed a single color are included in the basket and are eaten. Other foods in the basket include horseradish (suggesting the bitterness of Jesus Christ's suffering and because "Christ was given vinegar to drink during the crucifixion"), butter shaped like a lamb (suggesting innocence and the "Lamb of God") and studded with whole cloves in the form of a cross because "Jesus was wrapped in spices," ham, sausage, salt (suggesting fasting, self-denial, and the phrase "You are the salt of the earth"), cheese, a noodle hot-dish called macaron, oranges, apples, and candy. Rita adds, "In the Easter basket we put wheat seed along with the food to be blessed. Then in the spring you throw the [blessed] seed out on the field to grow [to ensure a bountiful harvest]."

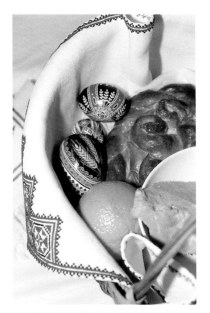

Pysanky, *Easter bread, orange, and ham in an embroidery-lined Easter basket.*

On Easter Sunday, outside of the church the parishioners, led by the priest, form a procession. Crosses, banners, an icon of Jesus Christ arisen, and a representation of the Holy Shroud are carried around the church three times while everybody follows. After circling the church, the procession stops at the front door. Agnes Palanuk (Dickinson) explains further: "[At the door,] the priest announces 'Christ is risen.'

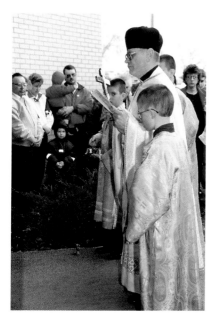

Procession on Easter morning at the front door of the St. John the Baptist Ukrainian Catholic Church in Belfield, ND.

He opens the door with a hand-held cross. The congregation pours into the church, singing 'Christ is risen from the dead, trampling death with death and to those in the tombs giving life.'" At the conclusion, the congregation sets out Easter baskets. The embroidered cloths covering the baskets are removed, and candles inserted into the *babka* are lit. The priest then blesses each basket with prayers and the sprinkling of Holy Water. Then, Josie explains, "People would stand around and exchange eggs, breads,

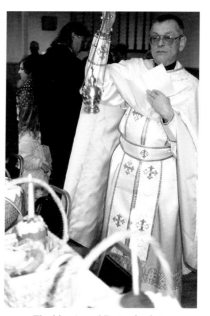

The blessing of Easter baskets.

and other foods. Exchanging things for what they didn't have. And everybody gives something to the Father so he would have a basket too." The first food eaten from the basket is a hard boiled egg that is dyed a single color. It is shared among family members as a sign of unity. The rest of the food is eaten to break the 40 days of fasting during Lent.

Pysanky and Their Interpretations by Julia Hurinenko

When interpreting the meaning of a *pysanka*, it's colors and designs are read as a whole to reveal a "story." The following *pysanky* serve as examples. For meanings of individual colors and designs see "*Pysanky* Symbolism" on pages 29-31.

Resurrection

"Christ carried the heavy cross to Calvary where he was crucified. He was forced to wear a crown of thorns on his sacred head. Mary, Christ's mother, shed many tears of sorrow. The tears are [represented by] the dots on the egg. Jesus, while on this earth, bore many crosses for the love of Humanity. The crosses [represent] suffering and the love of Humanity [is represented] by the flowers on the egg. Jesus was resurrected [as illustrated by the] light pointing upward on the cross. He went to Heaven [which is symbolized by] the stars on the egg. The endless straight and wavy lines around the egg symbolize eternity. Red color signifies the precious blood Jesus shed for us sinners."

The Three Suns

"The sun represents good fortune for all. The diamond indicates knowledge. The more people [from around the world] become knowledgeable, the less suffering (crosses) and problems (dots) there will be. Life will be more fulfilling. The color white suggests purity and innocence. Blue is good health. Red is happiness."

Wings of the White Dove

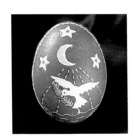

"The white dove is spreading peace (olive branch), love (flowers), success, and good fortune (stars) around the world. At night the moon lights the way for the white dove. The blue background suggests good health for all."

Cymbaly Making and Playing

Ukrainian folk music has developed through time, yet its sound has remained remarkably constant. This music was associated with pre-Christian winter solstice and spring ceremonies. With Christianity, however, Ukrainian musical traditions adapted to a new context in the singing of *kolady* (Christmas carols) in the winter and spring songs at Easter. When Ukrainians immigrated to North Dakota, they brought their love of music with them. It sustained families through tough times. Marie Makaruk (Dickinson) remembers, "I come from a family of nine, and we would sing all the time. We would always sing together as a family. My father loved to sing. He loved Ukrainian music. Then in the 1930s, the Great Depression

> *"When I die, let the dulcimer play for me."*
>
> —Josie Namyniuk

came. There would be sand storms that would go on for days and days and days. I remember the day the locusts came. I heard a hum, and a black cloud shut out the sun. The locusts covered everything. They were everywhere. They covered the walls of the house. They ate all the crops and even ate the paint off the walls. My dad never sang again after that. But we kids still sang. My dad would just listen to us kids sing. He loved to hear us [sing]."

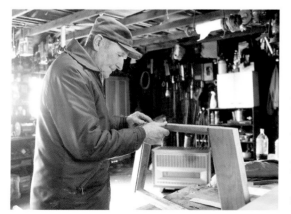

Bill Namyniuk in his shop constructing a cymbaly.

Such enduring sentiments regarding music is shared by other Ukrainian traditionalists like Bill and Josie Namyniuk (Belfield). For them, as for Marie, Ukrainian traditional music has a familial, social, and folk religious context. Bill makes and plays the *cymbaly*, a hammered dulcimer that uniquely defines Ukrainian folk music. It usually accompanies the violin and accordion. Bill's uncles were musicians who brought dulcimers to North Dakota. Bill has been making dulcimers for almost 70 years. In 1926, at the age of 12, he made his first instrument, learning from his uncles and brother, Mike. In return, he himself has taught several people to make and play the *cymbaly*, among whom is Mary

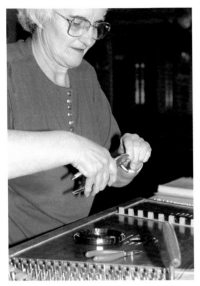

Mary Ann Krush stringing a cymbaly.

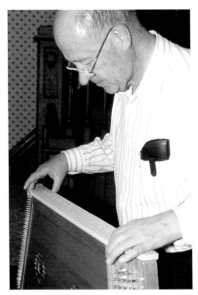

Dwaine Bolke fitting a decorative wooden front piece to a cymbaly.

Ann Krush (Fairfield). Mary Ann remarks, "The making and playing of the dulcimer is a challenge, and I like a challenge. I've always liked the sound of the dulcimer. There is so much to learn. For example, the sound of the dulcimer changes as the weather changes. When it is clear, hot, and sunny outside, the dulcimer makes a sharp, clear, and loud sound. When it is cloudy, cool, or rainy, it sounds dull and low."

Bill makes these trapezoidal-shaped dulcimers out of simple plywood or, if more elaborate, he may use oak for the front and back, birch for the sides, and pine for the top and bottom. Two sound holes are cut in the top of the instrument. The holes may be cut in the shape of an eight-pointed star or in other geometric designs. On the top, strung between pegs from one end to the other, are 105 piano wires with five strings per note. The wires are struck with wooden "hammers" to create the chording necessary for the tune.

Detail of chip-carved eight-pointed stars on front piece of a cymbaly.

Occasionally, Bill has the front of the dulcimer decorated with chip carving. Dwaine Bolke (Dickinson), an excellent chip carver, does this work. Dwaine recognizes the similarities in geometric designs between those found on *pysanky* and those used in wood carving. He often carves wooden boxes and crosses with Ukrainian designs that are similar to those found on Ukrainian decorated eggs.

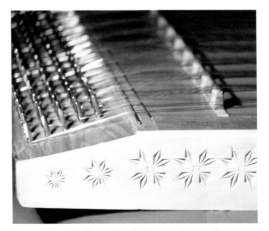

Detail of completed chip carving work.

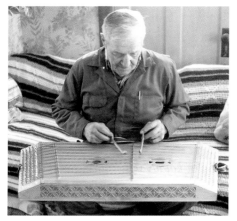
Bill Namyniuk playing music in his home.

Bill's older brother, Mike, also taught Bill to play the dulcimer, so Bill could accompany him while he played the violin. Bill recalls, "I was 14 years old when I started playing. I first played at a wedding." The music is very lively, sometimes melancholy, and geared toward energetic dancing. Specific dulcimer tunes are used for specific dances. The Cossack dance and the *kolomyeka*, for instance, are fast-paced dances involving high, almost acrobatic, kicking routines. Ray, Bill's son, adds, "A lot of the tunes played did not have names. The musicians would hum the tune to let the others [in the band] know what tune they wanted to play." As he grew older, Bill on the dulcimer, joined August Anheluk (Belfield) on the violin, and Laudie Burian (Manning) on the accordion, to perform throughout the area as a folk band called the Ukrainian Red Jackets. Josie, Bill's wife, recalls, "I went with Bill all the time. I took the kids along. Bill was always playing [the dulcimer]. If there was no dulcimer, people would not even think of having a party. ... Dulcimers are used for barn dances, social dances, anniversaries, and weddings. The dances usually took place within a person's home. Years ago, we had three-day anniversary and wedding parties."

Mary Ann Krush playing the cymbaly.

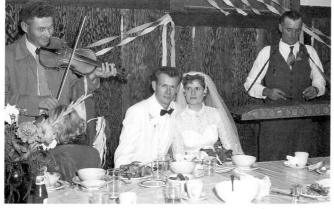
John Strwehenski on fiddle and Bill Namyniuk on cymbaly *played for many Ukrainian weddings.*

The hammered dulcimer, with the fiddle, is an essential part of the unofficial religious folk customs of Ukrainian weddings. Before a wedding, a blessing ceremony takes place at the home. Here, a folk band welcomes guests with music. Once all the guests have arrived, the ceremony begins. The bride's mother puts a veil and a periwinkle wreath on her daughter's head. The soon-to-be bride and groom kneel upon a *rushnyk* (embroidered ceremonial wedding cloth) as their parents hold a *kolach* above the bride and groom's heads and

impart a blessing. The dulcimer and violin music ushers every part of this ceremony, playing specific tunes for the "invitation march," the placement of the wreath, and even for the departure to the church.

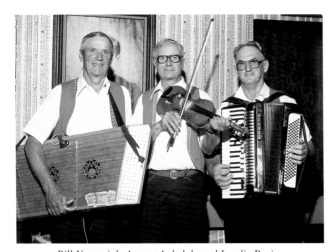

Bill Namyniuk, August Anheluk, and Laudie Burian were known as the folk band The Ukrainian Red Jackets. They performed for many celebrations in the Ukrainian community. There is a slot underneath the dollar shown in the corner of the dulcimer. This is where coins were removed after a night's worth of tipping by appreciative dancers.

After the official wedding ceremony in the church, folk traditions again take prominence at the reception. Josie says, "At wedding [receptions,] the [fiddler and dulcimer player] play as the guests come in the house. When someone comes to the house, the musicians meet them [and escort them to the house] with music. Every person that comes to the wedding [is escorted with music]. And every guest would [tip the musicians by] putting a dollar bill under the strings [of the dulcimer] or by dropping coins into the sound hole in appreciation. There were times the dulcimer was so heavy you could hardly carry it; sometimes as much as $120 in change." Roy Basaraba (Fairfield) adds, "The musicians are the first ones there to welcome each guest as they arrive, and the dulcimer players are always the last to leave the house." At the reception, a "master of ceremonies" conducts the rituals and festivities, all the while specific tunes are played. Music, with the dulcimer sounding the rhythm, is played when the reception begins, when the bridal party circles the supper table in dance, and when the couple's heads are tied with a *rushnyk* in unison like a *babushka*.

Glossary of Ukrainian Words

Atar—an ancient sun god whose symbol was an eight-pointed star or sun. Used throughout Ukrainian folk art, this design now symbolizes Jesus Christ, the Son of God.

Babka—a cylindrical, sweet-tasting, ritual bread sometimes glazed with a sugar frosting and used in Easter celebrations.

Babushka—a woven shawl that is worn over a woman's head.

Kolach (singular), *Kolachi* (plural)—a braided bread used for special or ceremonial occasions such as weddings, funerals, and welcoming ceremonies. The Christmas *kolachi* is a three-tiered, symbolic bread made of three *kolach*, and it serves as a centerpiece for the Christmas Eve meal.

Cymbaly—a hammered dulcimer. A trapezoidal wooden instrument strung with 105 piano wires. These wires are struck with wooden "hammers" to create the uniquely defining sound of Ukrainian folk music.

Didukh—a sheaf of wheat serving as a centerpiece for the Christmas Eve meal and symbolic of the souls of deceased family members; literally means "forefather."

Kistka—a "writing" tool used to apply wax to eggs as part of the design process in the *pysanky*, egg decorating tradition. A common type dispenses molten wax from a small funnel.

Kolady—Christmas carols sung without the aid of musical instruments. This tradition has its origins in pre-Christian winter solstice ceremonies.

Kolomyeka—a type of very energetic dance.

Korovai—a large, braided, sweet bread made for wedding celebrations. This ritually symbolic bread is decorated with doves, pine cones, rosettes, and flowers made of baked dough.

Kutia—an ancient dish made of boiled wheat mixed with honey and crushed poppy seeds and eaten on Christmas Eve.

Nyzynka—a reverse stitch used in Ukrainian embroidery.

Paska—a round, braided, ritual bread whose top often is decorated with crosses, flowers and leaves, rosettes, doves, and pine cones made of baked dough. It is used in Easter celebrations.

Pich—an outdoor, clay or earthen stove used to bake bread.

Pysanka (singular), *Pysanky* (plural)—eggs decorated with dyes and associated with Easter. Originally this pre-Christian tradition with its roots in ancient nature-based, sun ceremonies welcomed the return of spring and fertility.

Rushnyk (singular), *Rushnyky* (plural)—embroidered cloths or towels used in religious, ceremonial, and social occasions.

Zavolikania—a weaving stitch used in Ukrainian embroidery.

Pysanky Symbolism

Natural Dyes

Black	oak bark, green walnuts, young black maple leaves
Blue	red cabbage leaves
Brown	yellow onion skins, oak bark, coffee, tea, old walnuts
Green	dandelion leaves, rye, sunflower seeds, wheat, leaves, grass, moss, birch leaves
Orange	onion skins (shade of color changes the longer the skins are boiled), mixing yellow and red dyes
Pink	crocus flowers, prairie rose petals
Purple	crocus flowers, lead from indelible pencil, chokecherries, elderberry
Red	red onion skins, beets, red cabbage, rose hips, raspberries, plums
Tan	onion skins
Yellow	dandelion heads, onion skins, apple tree bark, lilac flowers, buckwheat husks
Bleach	sauerkraut juice
Other Colors	boiled colored rags or crepe paper

Meanings of Colors

Black	Eternity, Remembrance, Night
Blue	Good Health, Air, Sky, Higher Life, Trust, Water
Brown	Earth, Fertility
Green	Spring, Eternal Life, Growth, Good Health, Youth, Hope
Orange	Strength, Endurance, Passion Tempered with Wisdom, Power
Purple	Faith, Passion of Jesus Christ, Patience, Fasting
Red	Sun, Hope, Passion of Jesus Christ, Spirituality, Happiness, Strength, Harvest, Fire
White	Purity, Innocence, Birth
Yellow	Youth, Kindness, Love, Recognition, Reward, Wisdom

Meanings of Designs

Babka With Candle

Easter Bread, Resurrected Spirit of Jesus Christ (as the "Light of the World")

Birds

Fertility, Fulfillment of Wishes, Human Souls

Butterflies

Resurrection, Beauty

Cross

Christianity, Resurrection, God, Jesus Christ

Curls

Protection, Defense

Dots

Stars, Suns, Good Fortune, Happiness, Tears of the Virgin Mary, Problems

Diamonds

Knowledge

Doves

The Holy Spirit, Peace

Easter Lilies

Easter, Resurrection

Eight-Pointed Star/Eight-Pointed Sun

Son of God, God's Love Toward Man, God's Will, Symbol of *Atar*

Fish

Ancient Symbol of Christianity ("Jesus Christ as the fisher of men"), Baptism, Sacrifice

Flowers

Spring, Life, Growth, Beauty, Love

Grapes

Communion ("the growing church"), Wine, Wisdom

Ladders

The Way to Heaven, Prayers, Searching

Line Around Egg

Eternity ("never a beginning and never an ending")

Netting

Separation of Good and Evil, Jesus Christ Fishing for Men

Periwinkle

Love, Holy Trinity, Wedded Life

Pine Needles

Eternal Life, Youth, Health, Endurance

Poppies

Spring, Ukraine

Pussy Willows

Spring, Renewal, Palm Sunday and Holy Week

Ribbons

Water, Everlasting Life

Roosters

Resurrection ("the announcement of a new day"), Good Fortune

Spirals

Immortality

Stags, Deer

Strength, Wealth, Leadership

Stars

Heaven, Good Fortune

Tree

Tree of Life, Knowledge, Wisdom

Triangles

Holy Trinity (Father, Son, Holy Ghost), Naturalistic Trinity (fire, water, air); Birth, Life, and Death

Wheat

Fertility, Bountiful Harvest and Life

Wolves Teeth

Wisdom, Loyalty

Suggested Readings and Bibliography

Aberle, George P. *From the Steppes to the Prairies*, Bismarck, ND: Bismarck Tribune Company, 1963.

Chamberlin, William Henry. *The Ukraine: A Submerged Nation*, New York: The Macmillan Company, 1944.

Eirwen Jones, Mary. *A History of Western Embroidery*, New York: Watson-Guptill Publications, 1969.

Farley, Marta Pisetska. *Festive Ukrainian Cooking*, Pittsburgh, Pa.: University of Pittsburgh Press, 1990.

Faryna, Natalka, ed. *Ukrainian Canadiana*, Edmonton, Alberta: Ukrainian Women's Association of Canada, 1976.

Geist, Troyd A. *Faces of Identity, Hands of Skill: Folk Arts in North Dakota*, Bismarck, ND: North Dakota Council on the Arts, 1995.

Ickis, Marguerite. *Folk Arts and Crafts*, New York: Association Press, 1958.

Luciow, Johanna, Ann Kmit and Loretta Luciow. *Eggs Beautiful: How to Make Ukrainian Easter Eggs*, Minneapolis:
 Harrison, Smith-Lund Press, [1970s].

Martin, Christopher. *Prairie Patterns: Folk Arts in North Dakota*, Fargo, ND: North Dakota Council on the Arts, 1989.

Nakonechny, Joan. *Pysanka: Easter Egg Art*, Vernon, British Columbia, Canada: Joan Nakonechny, 1981.

Newall, Venitia. *An Egg at Easter: A Folklore Study*, Bloomington: Indiana University Press, 1971.

Osadsa, Tanya. *Pysanky and Their Symbols*, New York: The Ukrainian Museum, 1980.

Palanuk, Agnes, and Jaroslaw Sztendera. *Rites of Spring*, Dickinson, ND: The Ukrainian Cultural Institute of North Dakota, 1993.

Palanuk, Agnes, and Jaroslaw Sztendera. *Rites of Summer*, Dickinson, ND: The Ukrainian Cultural Institute of North Dakota, 1994.

Sherman, William C. *Prairie Mosaic: An Ethnic Atlas of Rural North Dakota*, Fargo, ND: North Dakota Institute for Regional Studies, 1983.

Sherman, William C., and Playford Thorson, eds. *Plains Folk: North Dakota's Ethnic History*, Fargo, ND: The North Dakota Institute for Regional Studies, 1986.

Tkachuk, Mary, Marie Kishchuk, and Alice Nicholaichuk. *Pysanka: Icon of the Universe*, Saskatoon, Sask., Canada: The Ukrainian Museum, 1977.

Vaughn, Mary Ann Woloch. *Ukrainian Easter*: Traditions, Folk Customs, and Recipes, Coralville, Iowa: Communications Printing, 1982.

Interviews with Ukrainian Folk Artists and Traditionalists

Betty and Mike Baranko, March 25, 1987; January 6, 1996.

Pearl Basaraba, October 14, 1986.

Roy and Ann Basaraba, May 13, 1995; January 7, April 15, 1996.

Dwaine Bolke, February 13, March 25, 1996.

Angie Chruszch, August 10, 1994; April 27, 1995.

Josephine Gregory, April 15, 1996.

Julia Hurinenko, January 8, 1996.

Marjo Hurinenko, January 8, 1996.

Mary Ann Krush, June 19, 1996.

Marie Makaruk, January 9, February 28, 1996.

Josie and William Namyniuk, February 9, 1989; March 28, 1993; April 14, 1996.

Ray Namyniuk, April 14, 1996.

Martha Namyniuk, February 28, 1992; August 19, 1994; January 6, February 14, March 29, 1996.

Agnes Palanuk, January 6, January 8, February 9, June 3, 1996.

Rita and Nick Zaharia, January 26, April 2, 1996.